Carolina Collects

This exhibition is generously sponsored by

CAROLINA FIRST

Hilliard Family
Foundation

NATIONAL
ENDOWMENT
FOR THE ARTS
A great nation
deserves great art

This project is supported, in part, by an award from the National Endowment for the Arts.

This catalogue has been published in conjunction with
Carolina Collects,
an exhibition organized by the Columbia Museum of Art,
June 27 – August 17, 2008.

Catalogue compiled by Todd Herman, chief curator and curator of
European Art, and Brian Lang, associate curator of decorative arts and
generously underwritten by Dr. Suzan D. Boyd and Mr. M. Edward Sellers.

Columbia Museum of Art

Published in 2008 by the Columbia Museum of Art
P.O. Box 2068, Columbia, South Carolina 29202
columbiamuseum.org

Support for the Columbia Museum of Art is provided by Richland County, the City of Columbia, the Contributors of the
United Arts Fund of the Cultural Council of Richland and Lexington Counties, the South Carolina Arts Commission,
which receives support from the National Endowment for the Arts, citizens and corporations of the Midlands,
and by the Commission of the Columbia Museum of Art.

The Museum's Exhibition Program is made possible, in part, by the Commission of the Columbia Museum of Art.

Design by Lauren Landers
Photography by Jonathan Goley

ISBN-13: 978-0-9818064-0-2
ISBN-10: 0-9818064-0-6

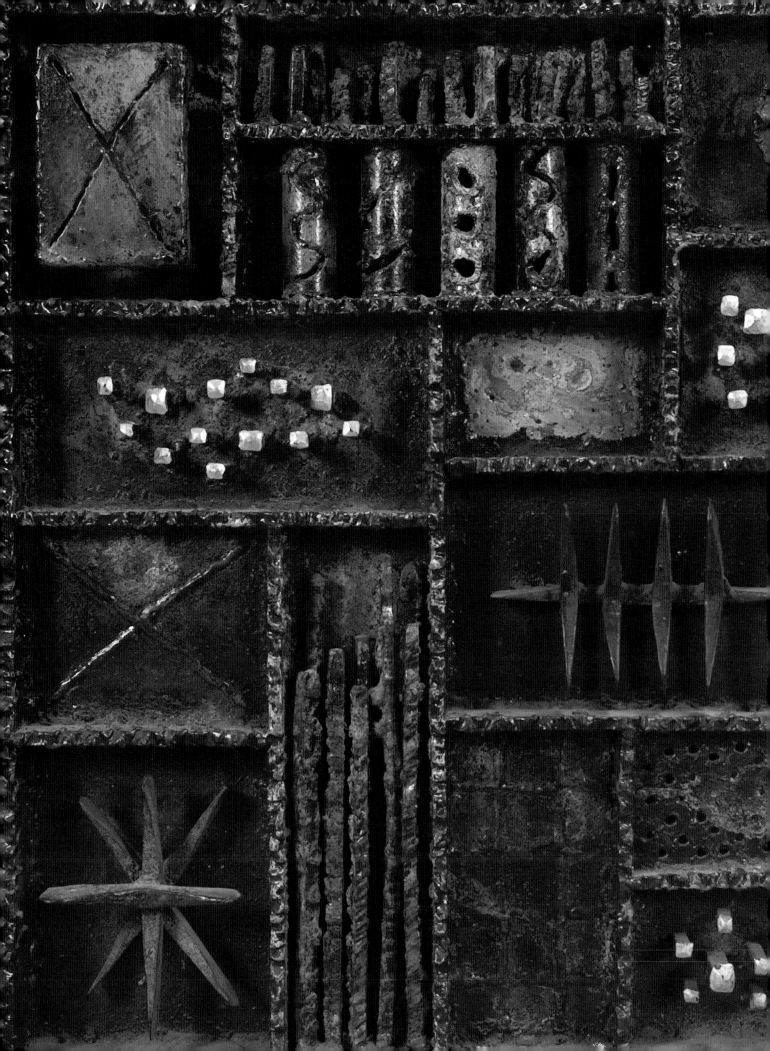

Director's Foreword ···

In 2008, the Columbia Museum of Art celebrates the 10th anniversary of its significant expansion and move to its new, superb modern building on Columbia's Main Street. To commemorate this milestone, chief curator Todd Herman and I bandied about how to appropriately mark this moment in the Museum's history. As we talked, the idea of celebrating the South Carolina collector emerged as a wonderful way to recognize the inspiration of an individual's collecting passion and its harmony with the Museum's mission and vision.

We have selected works that mirror the key areas of the Museum's own collection by including the very best of European, American and Asian fine and decorative arts from collections throughout the state as the central theme of this exhibition. This exhibition reflects our international collecting mission along with the diversity of Southern heritage and community. I am very grateful to the more than 65 collectors who generously gave of their time and treasures to make this exhibition a reality. Without them, these glorious works of art would not have been able to be seen by visitors from throughout the Southeast, bringing recognition to the cultural riches in South Carolina.

This exhibition reflects the geographic diversity of South Carolina by including collections from the Upstate area to the Lowcountry, to the Pee Dee and the beaches, the centerpoint of Columbia and the Midlands, from Beaufort County and Hilton Head Island in the south to the historic horse communities of Aiken and Camden. As a dynamic cultural resource for citizens statewide, the Museum gives the communities of South Carolina a "window on the world," as the only museum in the state with an extensive collection and special exhibitions of art from around America and across the globe.

The core of the Museum's collection is, in fact, a happy result of individual collecting passions: a generous donation by two brothers in the 1950s and 1960s, Samuel H. Kress and Rush Kress. These two astute individuals directed the first collecting focus for the Columbia Museum of Art in a most profound way. Because of their enthusiasm and commitment to building the collecting strength of regional museums, the Museum became the repository of one of their largest art donations of European art outside of their renowned gifts to the National Gallery of Art in Washington, D.C. and the Metropolitan Museum of Art in New York.

As the years have unfolded, the Museum has rounded out its mission to focus on European and American fine and decorative arts, including paintings, works on paper, sculpture, porcelain, furniture, glass and photography. Thanks to a spectacular gift in 2007 from Dr. Robert Y. Turner of Philadelphia, the Museum has now also developed a solid base in Asian art, particularly Chinese. It is through generous donors that the Museum is able to build and grow its collection.

The Museum is a beacon of cultural life and development in the heart of South Carolina's capital, contributing to the economic growth and vibrancy of the region and state. The Columbia Museum of Art is a powerful, evolving symbol of South Carolina's rich cultural heritage. The Museum connects people to one another and to art in a social environment that nurtures diverse interests and unique experiences. We are steadily transforming the Museum into a major destination for the arts in the region and continue to evolve into a community leader in culture and education.

I would like to thank the Museum's board of directors for their enthusiastic support of this exhibition, in particular, former museum board president Dr. Suzan D. Boyd and her husband M. Edward Sellers, for their contribution to underwrite this exhibition catalogue, and board

member Kathryn Stuart and the Hilliard Family Foundation for their support for this exhibition. As the exhibition's major corporate sponsor, Carolina First gave its commitment to this project as part of its long-standing contributions to the arts. My deep appreciation goes to executives Mack Whittle, CEO; David Lominack, Midlands President, and Michael Kapp, Executive Vice President and former museum board member, for their bank's generous leadership gift in presenting this exhibition to the people of South Carolina. I also thank the National Endowment for the Arts' Challenge America grant initiative for their whole-hearted support of this project.

My special thanks go to the accomplishments of the Museum's two curators who organized this exhibition and compiled this catalogue, Dr. Todd Herman, chief curator and curator of European art, and Brian J. Lang, associate curator of decorative arts. They are to be congratulated for all of the detailed and careful planning that has gone into this exhibition. We all have enjoyed the new friends and connections that we have made during this selection process. And lastly, I toast the people of South Carolina

for their embrace of the Museum's commitment to excellence, their curiosity about art, and their desire for reflection and beauty.

Karen Brosius
Executive Director
Columbia Museum of Art

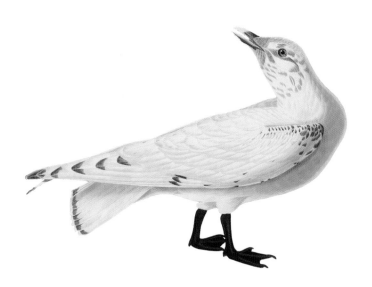

Sponsor's Foreword

Carolina First is honored to be the presenting sponsor for the Columbia Museum of Art's *Carolina Collects* exhibition. This unique "home grown" exhibition will give visitors a first-hand look into private collections from across the state of South Carolina not normally accessible to the public. Throughout the year, the Museum's extensive collection is an attraction for visitors from around the world, and *Carolina Collects* will continue to provide vital support for the growth of this great cultural treasure.

We are proud of our community and our long relationship with the Columbia Museum of Art. We are pleased to call the Museum our neighbor, and we congratulate them on their 10-year anniversary on Main Street. Along with many other individuals and businesses, Carolina First has supported the Museum through the Art Fund, the Capital Campaign and various exhibitions.

Carolina First is fortunate to be able to give back to the Midlands and other South Carolina communities. We feel that exposure to the arts is a necessity for the educational experiences of our youth and the quality of life for all. We believe art is fundamental to the growth, prosperity and well-being of a community. Because of this core value, Carolina First supports the arts in the many areas it serves.

We are grateful for the opportunity to support *Carolina Collects* and to all of you who join us in support of the Columbia Museum of Art. It is an institution of which we all can be proud!

Introductory Essay ···

Carolina Collects is a celebration — a celebration of the 10 years of the Columbia Museum of Art at its downtown, Main street location, and a celebration of the spirit of private collectors who have been instrumental in the formation and continued vitality of this museum and others throughout the world. Like most museums of its kind, the Columbia Museum of Art began with a small group of like-minded local citizens who felt their lives in need of a visible and sustainable cultural structure — a place to inspire and foster intellectual discoveries and offer educational opportunities for young and old alike.

The vision began with the formation of the Columbia Art Association in 1915. At a meeting on January 12, 1916 in the YMCA, the 64 charter members formally elected their first president, University of South Carolina history professor, Yates Snowden. Without a collection or a designated meeting place, for the next thirty-five years the Association met in homes and civic buildings to listen to music and lectures and present temporary exhibitions. It was the donation of the collection of Mr. and Mrs. Edwin G. Seibels in 1944 that made it necessary to locate or build a permanent brick and mortar home for the Museum. Their generosity inspired others to donate works of art to the new Columbia Museum of Art, which opened its doors to the public in March of 1950 in the renovated Taylor mansion on Senate Street on the outer-ring of downtown Columbia and in close proximity to the University of South Carolina.

Subsequent major gifts to the Museum by private collectors have defined its collection, identity and mission. The most significant of these were the gifts in 1954 and 1962 of more than 50 Old Master paintings and sculptures from the Samuel H. Kress Foundation. Further donations came from local collectors, and those farther afield with ties to South Carolina, which resulted in the addition of names such as Monet, Chase, Tiffany and Ambrosius Benson to name but a few. More recently the Museum has received gifts of contemporary glass, modern and contemporary works on paper, and the Robert Y. Turner collection, which included modern paintings and sculpture (Motherwell, Avery, Cornell, and Bertoia), a group of ancient Roman portrait heads, and an impressive collection of Chinese ceramics and sculpture.

The collection is currently housed in a state-of-the-art facility in the heart of downtown Columbia. A testament to the potential of adaptive re-use projects, the Columbia Museum of Art and the adjacent Boyd Plaza were molded out of two long-standing — but abandoned — downtown department stores. The new building, with more than 20,000 square feet of gallery and exhibition space (and a footprint of 120,000 square feet) opened to the public during a gala weekend in July of 1998 that attracted more than 25,000 visitors. Two years later, the Museum celebrated its 50th anniversary that sparked a new wave of donations including over 30 works on paper from the private collection of South Carolina native Jasper Johns. With acquisition budgets at museums continually being squeezed by internal and external forces, a museum's relationship with private collectors is today more vital than ever.

In many ways, *Carolina Collects* is the fulfillment of the dream of William Beeson, former executive director of the Arts Council of Spartanburg County, who upon moving to Spartanburg from Houston in the late 1960s, proposed to create a show from private collections in South Carolina. The reaction from a friend was, "Oh dear, no. You'd never get much that way. Better do both Carolinas." And so in 1970, Beeson opened *The Carolinas Collect* at Wofford College in Spartanburg. His friend's concerns regarding the availability of museum quality work residing in South Carolina homes, recall those of Dr. Jack Craft, the first

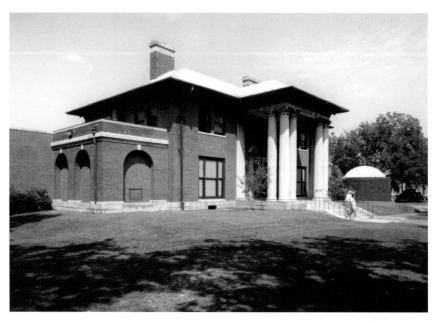

The former Columbia Museum of Art at the Thomas Taylor Mansion at the corner of Bull and Senate Streets

director of the Columbia Museum of Art, who in 1950 assessed his fledgling museum in the following way: " The art collection was minimal, with slight prospects at hand for additions…." It must be admitted that as our associate curator Brian Lang and I stepped out on Beeson's limb, we were not at all sure that our predecessors were incorrect and that we would be able produce enough material of a high standard to occupy the four galleries (almost 3,600 square feet) on our first floor. A remarkable amount of sleuthing, word of mouth, board participation, and social connections were essential to learning of possible collections and gaining access to the owner — one does not merely call and say, "I understand you have a Renoir painting. Can I borrow it?" Very quickly our efforts turned into a networking tour-de-force that took us from Hilton Head to Greenville and from Aiken to Charleston. With a few notable exceptions, what was uncovered during countless 'house calls' was not an unexpected snapshot of a state steeped in family history and with a bustling port city. Portraits abound, as do export wares from England and China, as well as southern and English furniture and silver, and a love of 'art pottery' undoubtedly linked to the historical production of pottery in areas of the state such as

The present Columbia Museum of Art on the corner of Main and Hampton Streets

Edgefield. A few collections were already known — fine American furniture, American Impressionist paintings, Tiffany glass, Chinese export porcelain, and Southern art. It was the unanticipated discoveries — a rare Cartier clock in the Chinese manner, a massive collection of contemporary photography and works on paper, a collection of French Impressionist and Post-Impressionist paintings and sculpture, a stellar collection of mid-century modern furniture, American 19th-century landscape paintings, and an impressive collection of 18th-19th century European paintings and sculpture — that kept us invigorated and willing to track down every lead. In the end, what would have vindicated Beeson and delighted Jack Craft, was the pleasantly surprising fact that we were faced with an embarrassment of riches necessitating not only an expansion of the exhibition to occupy all six galleries on the first floor (5,600 square feet), but some very difficult and heart-wrenching cuts from our list of more than 400 preferred works. As it stands, the exhibition contains more than 280 examples of fine and decorative arts from Europe, America and Asia.

The exhibition comprises works by names familiar to most museum goers — Corot, Matisse, Diebenkorn, Picasso, Renoir, Degas, Sully, Benton, Twombly, Dine, Wyeth, Toulouse-Lautrec, Gehry and Warhol — and others who, although not part of the everyday lexicon, are nonetheless major artistic lights within the history of art — Inness, Peale, Glackens, Saint-Gaudens, Lucero, Cadmus, Boilly, Wright of Derby, Diane Arbus, among many other equally important known and anonymous artisans who created ravishing works of art throughout the centuries. Just as fascinating as finding a superb collection or single object, were the stories and philosophies behind why or how they were collected. Tales of 'unique' family personalities are endlessly captivating — the uncle who was a physician to American celebrities in Paris, the mother who lived in the same New York apartment building as a group of artists, or the relative who traded a pure-bred puppy for a painting — as are the motivations behind a collector's desire to accumulate the art of one particular region, culture, period or medium. All are unique and reflect the personalities of these collectors.

Unlike its predecessors, from the outset, *Carolina Collects* was meant to include not only two-dimensional work (paintings, prints and photographs) but also the decorative arts (furniture,

silver, porcelain, sculpture, etc) as a mirror of the Museum's own collection and mission. Because of the nature of this exhibition, no attempt was made to trace the history of artistic production through representative examples of the major movements and styles. The visitor will find multiple examples from one particular period and none from another. Structure is found in the broadest organizational terms — American Art, Asian Art, European Art and Modern and Contemporary Art. It is a 'potpourri', a 'greatest hits' encompassing a variety of ideas, styles, techniques, media and subject matter that offers the visitor the opportunity to digest the familiar with the unfamiliar and to ponder the diversity of art collected in South Carolina.

However, for all its plurality and disparate elements, a unifying theme does emerge — the universal longing to possess objects of beauty. Anyone who has been struck by this 'bug' can appreciate the words of retired University of South Carolina art history professor, Charles R. Mack, himself a veteran of two such exhibitions, describing this human condition in pathological terms as "that most seductively pleasant infection — the disease of collecting — [that] can afflict even persons of modest means."

Todd Herman, Ph.D.
Chief Curator and Curator of European Art

Acknowledgments ···

An exhibition of this magnitude could not have become a reality without the dedicated support of numerous people affiliated with the Columbia Museum of Art. Most importantly are the lenders, who were generous in granting access to their collections and in agreeing to share their treasures with the Museum and its audience. Members of the Museum Board and the Collections Committee equally were generous in loaning works from their own collections, in recommending other lenders, and promoting the exhibition concept within the South Carolina collecting community. Special gratitude also goes to our Director, Karen Brosius, and her husband Willson Powell. Together, they tirelessly worked every angle possible within their vast network of friends and colleagues to identify potential lenders and to solicit their participation. At the Museum we would like to thank Ellen Woodoff, Director of Marketing and Communications, for managing all aspects regarding the promotion of the exhibition, and to Lauren Landers, Graphic Designer, whose creative energy and formidable design skills produced this handsome catalogue. Certainly, members of the Development Department should be recognized, including Scott Nolan, Director; Caroline Quillen, Assistant Director; Meagan Warren, Development Manager; and Robin O'Neil, former Head of Donor Relations and Donor Development; all were instrumental in identifying potential lenders and securing corporate sponsorship for the exhibition.

Within the curatorial department, we must extend our deepest gratitude to our colleagues who ensured that all aspects of the

exhibition ran smoothly and that it ultimately came to fruition. Noelle Rice, Curatorial Assistant, deftly managed myriad administrative aspects of the exhibition and painstakingly proofread and formatted all the object label copy. Cindy Connor, Museum Registrar, together with her registration assistants, Halie Nowell and Alice Booknight, coordinated shipment of many of the objects and thoroughly catalogued and prepared condition reports for every object once they arrived at the Museum. Mike Dwyer, exhibition designer and preparator, worked so diligently — and with regular good humor — to make installation of the exhibition a reality. A special thank you is extended to Jonathan Goley, Assistant Preparator, who in addition to his regular duties was able to work miracles with a camera and a computer to make the objects look their best for the catalogue. Last, but certainly not least, assisting the curatorial team were a duo of talented interns, Elizabeth Patton and Ali Collins, whose contributions helped to make the organization of this show run smoothly.

And always, to our families, who endure the long hours along with us, and without whose constant support none of this would be possible.

Todd Herman, Ph.D.
Chief Curator and Curator of European Art

Brian J. Lang
Associate Curator of Decorative Arts

Illustrated Checklist

ASIAN art

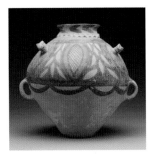

1. *Storage Jar (Kuan)*
Chinese; Gansu or Qinghai Province
Majiayao Yangshao Culture, Banshan phase
Neolithic Period, c. 2800-2200 B.C.
Earthenware with pigment
Collection of Myrna Kennedy, Union SC

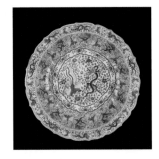

6. *Large Plate or Basin*
Chinese; Jingdezhen
Ming Dynasty, 1368-1644; Wanli period, 1573-1620
Porcelain with underglaze cobalt enamel and
overglaze polychrome enamels
Private Collection, Florence SC

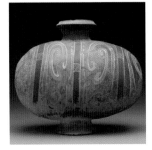

2. *Storage Jar (Kuan)*
Chinese
Warring States Period, 475 B.C. – 221 A.D.
Impressed earthenware
Collection of Myrna Kennedy, Union SC

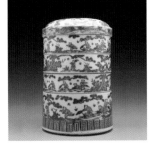

7. *Plate, "Riots of Rotterdam"*
Chinese, for the Dutch market
Qing Dynasty, 1644-1911; Kangxi period, 1662-1722
Porcelain with underglaze cobalt enamel, 1690-1695
Private Collection, SC

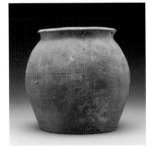

3. *Cocoon-Shaped Jar (Mingqi) with Cloud-Scroll Design*
Chinese; Henan Province
Western Han Dynasty, 206 B.C. – 9 A.D.
Earthenware with pigment
Collection of Myrna Kennedy, Union SC

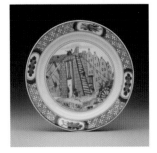

8. *Four-tiered Box and Cover*
Chinese; Jingdezhen
Qing Dynasty, 1644-1911; Kangxi period, 1662-1722
Porcelain with underglaze cobalt enamel, c. 1700-1720
Collection of Myrna Kennedy, Union SC

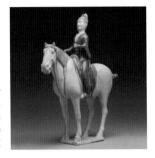

4. *Tomb Figure of a Horse and Rider*
Chinese
Tang Dynasty, 618-906
Sansai-glazed earthenware, c. 700-750
Collection of Joyce and Bob Hampton, Blythewood SC

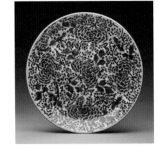

9. *Charger*
Chinese, for the Near Eastern market
Qing Dynasty, 1644-1911; Kangxi period, 1662-1722
Porcelain with underglaze cobalt enamel, c. 1700-1720
Private Collection, SC

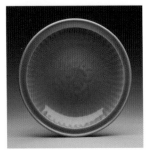

5. *Bowl*
Chinese; Chekiang Province
Song Dynasty, 960-1279
Earthenware with celadon glaze, c. 1100
Private Collection, Richland County SC

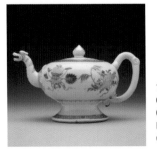

10. *Teapot on Molded Stand*
Chinese, for the Western market
Qing Dynasty, 1644-1911; Kangxi period, 1662-1722
Porcelain with gilt and overglaze polychrome enamels, c. 1720
Collection of Sarah Lund Donnem, Charleston SC

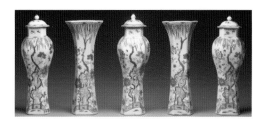

11. *Five Piece Garniture;* Chinese, for the Western market; Qing Dynasty, 1644-1911; Kangxi period, 1662-1722
Porcelain with gilt and overglaze polychrome enamels, c. 1700-1725; Private Collection, SC

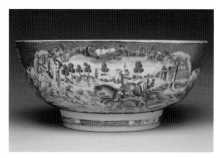

16. *Punch Bowl with Hunt Scene*
Chinese; Jingdezhen
Qing Dynasty, 1644-1911;
Qianlong period, 1736-1795
Porcelain with gilt and overglaze
polychrome enamels, c. 1785
Collection of Joyce and Bob Hampton,
Blythewood SC

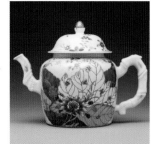

12. *Teapot, "Tobacco Leaf"*
Chinese, for the Western market
Qing Dynasty, 1644-1911; Qianlong period, 1736-1795
Porcelain with gilt and overglaze polychrome enamels,
c. 1760-1780
Private Collection, SC

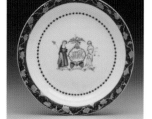

17. *Coffee Cup and Saucer,*
"Mars Caressing Venus"
Chinese, for the Continental market
Qing Dynasty, 1644-1911;
Qianlong period, 1736-1795
Porcelain with gilt and overglaze
polychrome enamels, c. 1745
Collection of W.R. Sikes III,
Orangeburg SC

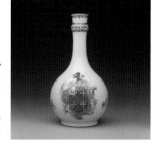

13. *Bottle, "Arms of Chase"*
Chinese, for the English market
Qing Dynasty, 1644-1911; Qianlong period, 1736-1795
Porcelain with gilt and overglaze polychrome enamels,
c. 1750
Private Collection, SC

18. *Saucer, "Arms of New York"*
Chinese, for the American market
Qing Dynasty, 1644-1911; Jiaqing period, 1796-1820
Porcelain with gilt and overglaze polychrome enamels,
c. 1790-1800
Private Collection, SC

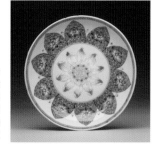

14. *Plate with Lotus Leaf Design*
Chinese, for the Near Eastern market
Qing Dynasty, 1644-1911; Qianlong period, 1736-1795
Porcelain with gilt, underglaze cobalt enamel and
overglaze polychrome enamels, c. 1750
Collection of Joyce and Bob Hampton, Blythewood SC

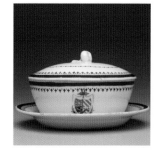

19. *Butter Tub and Underdish, "Arms of Chadwick"*
Chinese, for the English market
Qing Dynasty, 1644-1911; Qianlong period, 1736-1795
Porcelain with gilt and overglaze polychrome enamels,
1791
Private Collection, SC

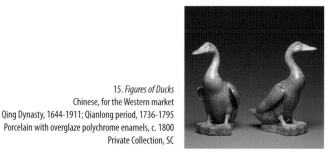

15. *Figures of Ducks*
Chinese, for the Western market
Qing Dynasty, 1644-1911; Qianlong period, 1736-1795
Porcelain with overglaze polychrome enamels, c. 1800
Private Collection, SC

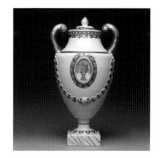

20. *Pistol-Handled Urn with Cover, "L'Urne Mystérieuse"*
Chinese, for the French market
Qing Dynasty, 1644-1911; Jiaqing period, 1796-1820
Porcelain with gilt and overglaze polychrome enamels,
c. 1795
Private Collection, SC

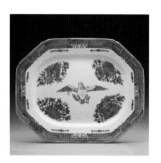

21. *Platter*
Chinese, for the American market
Qing Dynasty, 1644-1911; Jiaqing period, 1796-1820
Porcelain with gilt and overglaze green enamel, c. 1800
Private Collection, SC

26. *Platter, "Arms of Charles Izard Manigault"*
Chinese, for the American market
Qing Dynasty, 1644-1911; Jiaqing period, 1796-1820
Porcelain with gilt and overglaze enamel, 1818-1823
Collection of Mrs. M. Tucker Laffitte, Jr., Columbia SC

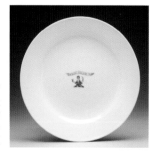

22. *Plate, "Cause Caused It"*
Chinese, for the English market
Qing Dynasty, 1644-1911; Jiaqing period, 1796-1820
Porcelain with gilt and overglaze sepia enamel, c. 1800-1810
Collection of Sarah Lund Donnem, Charleston SC

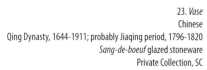

27. *Teapot, Creamer and Sugar Bowl*; Chinese, for the Near Eastern market; Qing Dynasty, 1644-1911;
Daoguang period, 1821-1850; Silver, c. 1850; Collection of Myrna Kennedy, Union SC

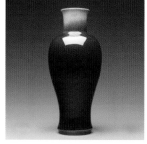

23. *Vase*
Chinese
Qing Dynasty, 1644-1911; probably Jiaqing period, 1796-1820
Sang-de-boeuf glazed stoneware
Private Collection, SC

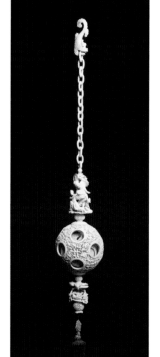

24. *Jar with Dragon Handle*
Chinese; possibly Changsha, Hunan Province
Qing Dynasty, 1644-1911; probably Jiaqing period, 1796-1820
Glazed earthenware
Collection of Myrna Kennedy, Union SC

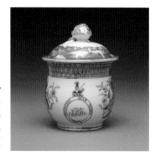

25. *Pot-de-crème, "Crest of Gabriel Henry Manigault"*
Chinese, for the American market
Qing Dynasty, 1644-1911; Jiaqing period, 1796-1820
Porcelain with gilt and overglaze enamel, c. 1820
Private Collection, SC

28. *Puzzle Ball*
Chinese
Qing Dynasty, 1644-1911; Daoguang period, 1821-1850
Ivory, c. 1850
Collection of Mrs. M. Tucker Laffitte, Jr., Columbia SC

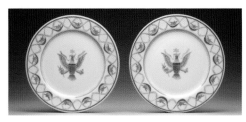

29. *Pair of Plates with Eagles;* Possibly Chinese, for the American market; Porcelain with gilt and overglaze polychrome enamels; mid-late 19th century; Collection of Sarah Lund Donnem, Charleston SC

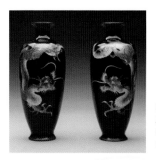

34. *Pair of Vases with Dragons*
Japanese
Cloisonné, c. 1880-1890
Private Collection, SC

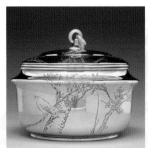

30. *Covered Dish*
Chinese, for the export market
Qing Dynasty, 1644-1911; Guangxu period, 1875-1908
Silver and jade, c. 1890-1910
Private Collection, SC

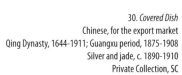

35. *Ewer*
Korean
Koryo Dynasty, 936-1392
Stoneware with celadon glaze over underglaze iron oxide, 11th or 12th century
Collection of Myrna Kennedy, Union SC

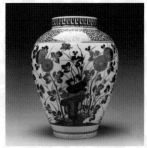

31. *Ginger Jar*
Japanese; Arita, Saga Prefecture, Kyushu Region
Edo period, 1603-1867
Porcelain with underglaze cobalt enamel *(sometsuke)*, late 17th century
Private Collection, SC

·························· works on paper

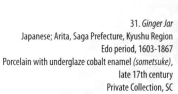

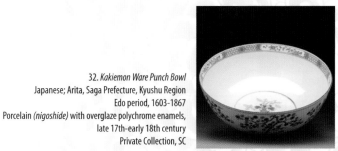

32. *Kakiemon Ware Punch Bowl*
Japanese; Arita, Saga Prefecture, Kyushu Region
Edo period, 1603-1867
Porcelain *(nigoshide)* with overglaze polychrome enamels, late 17th-early 18th century
Private Collection, SC

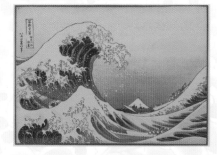

36. Katsushika Hokusai
Japanese, 1760-1849
The Great Wave off Kanagawa, from a series of *"Thirty-six Views of Mount Fuji"*
Handcolored woodblock print, 1823-29
Collection of Bobby and Sally Lyles, Columbia SC

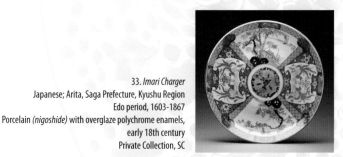

33. *Imari Charger*
Japanese; Arita, Saga Prefecture, Kyushu Region
Edo period, 1603-1867
Porcelain *(nigoshide)* with overglaze polychrome enamels, early 18th century
Private Collection, SC

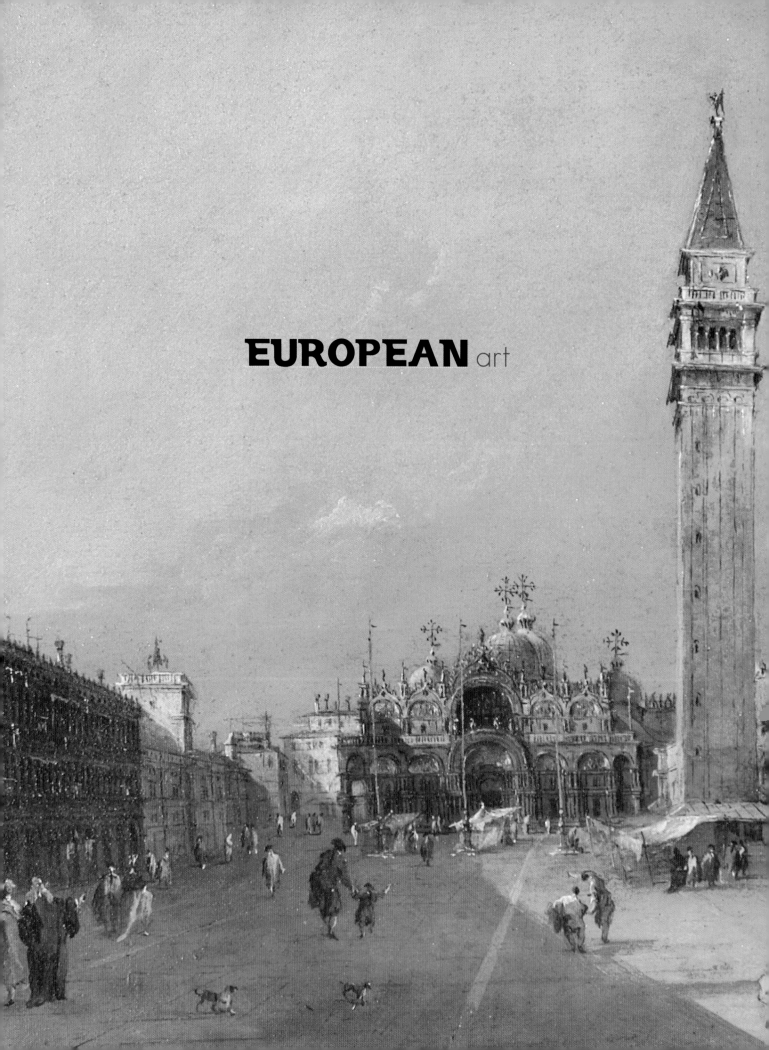

EUROPEAN art

1. Anonymous
Dutch
Tile
Tin-glazed earthenware, c. 1670
Private Collection, West Columbia SC

6. Anonymous
French
Japanned Commode
Wood, marble, lacquer and ormolu, c. 1770
Private Collection, Colleton County SC

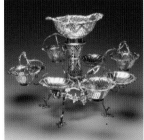

2. Maker unidentified, marked "EB"
Irish; Dublin
Epergne
Silver, 1746
Private Collection, SC

7. Anonymous
English
Tea Caddy
Tortoise shell, wood, brass and ivory, 1770-1790
Private Collection, Columbia SC

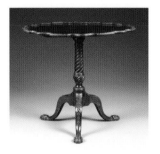

3. Anonymous
English
Tea Table
Mahogany, c. 1760-1780
Private Collection, SC

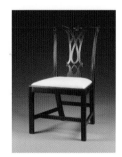

8. Anonymous
English
Side Chair
Mahogany, c. 1770-1785
Collection of Mr. and Mrs. Robert H. Kennedy, Columbia SC

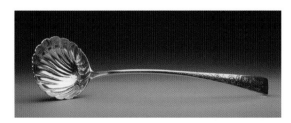

4. Maker unidentified, marked "IC"; Irish; Dublin;
Ladle, Silver, 1769; Collection of Mr. and Mrs. Robert H. Kennedy, Columbia SC

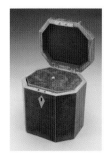

9. Anonymous
English
Tea Caddy
Wood, burl walnut veneer, ivory, inlay and brass, c. 1790
Private Collection, Columbia SC

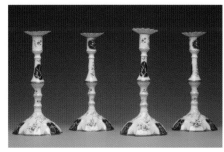

5. Anonymous
English; South Staffordshire
Set of Four Candlesticks
Enamel on metal, c. 1770
Collection of Sarah Lund Donnem,
Charleston SC

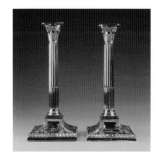

10. William Abdy (attributed to)
English; active in London, 1763-1799
Pair of Candlesticks
Silver, 1769
Private Collection, Florence SC

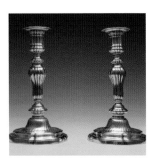

11. Edmé Pierre Balzac
French, 1705-1790
Pair of Candlesticks
Silver, 1744-1745
Private Collection, Richland County SC

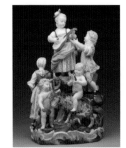

16. Meissen Royal Saxon Porcelain Manufactory
German
Venus Clipping the Wings of Cupid
Hard-paste porcelain with overglaze polychrome enamels,
last half of the 19th century
Private Collection, Columbia SC

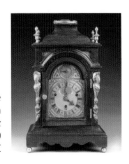

12. George Clarke
English, dates unknown
Bracket Clock
Walnut, brass, steel, ormolu and glass, c. 1750
Private Collection, Columbia SC

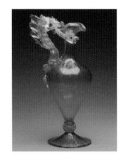

17. Meissen Royal Saxon Porcelain Manufactory
German
Allegory with Musicians in a Rocky Landscape
Hard-paste porcelain with overglaze polychrome enamels,
last half of the 19th century
Private Collection, Columbia SC

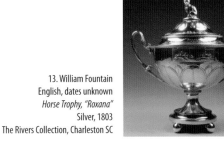

13. William Fountain
English, dates unknown
Horse Trophy, "Roxana"
Silver, 1803
The Rivers Collection, Charleston SC

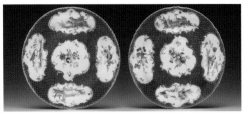

18. Antonio Salviati (Italian, c. 1877-1914), manufacturer
Probably Giuseppi Barovier (Italian, 1853-1942), maker
Vase with Dragon Handle
Baloton-blown glass and gold leaf, c. 1890
Private Collection, SC

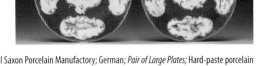

14. Meissen Royal Saxon Porcelain Manufactory; German; *Pair of Large Plates;* Hard-paste porcelain
with gilt and overglaze polychrome enamels, c. 1760; Collection of Sarah Lund Donnem, Charleston SC

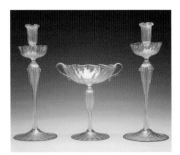

19. Probably Antonio Salviati, maker
Italian, c. 1877-1914
Pair of Candlesticks and Compote
Blown glass, green and rose *polveri*, and gold leaf,
c. 1890-1910
Private Collection, Columbia SC

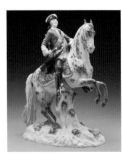

15. Meissen Royal Saxon Porcelain Manufactory
Friedrich Elias Meyer (German, 1723-1785), modeler
German
Statue of August III
Porcelain, modeled 1752 (this example c. late 18th century)
Private Collection, SC

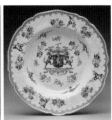
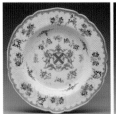

20. Edmé Samson; Samson, Edmé et Cie (Samson Ceramics), manufacturer
French, 1810-1891; active in Paris 1845-1969; *Two Plates with Pseudo Coats-of-Arms,*
Hard-paste porcelain with gilt and overglaze polychrome enamels, c. 1850-1860; Private Collection, SC

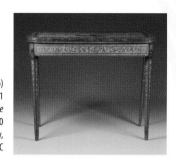

21. George Seddon (attributed to)
English, 1727-1801
Card Table
Painted satinwood and inlay, c. 1790
Collection of Mr. and Mrs. T. Russell Rooney,
Columbia SC

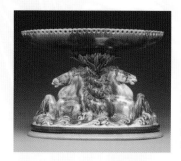

26. Wedgwood Pottery
English; active 1759-present
Compote with Sea Horse Figures
Glazed earthenware, 1867
Collection of Joyce and Bob Hampton, Blythewood SC

22. Sèvres Porcelain Manufactory
French; Vincennes; active 1738-present
F. Goupil (French, dates unknown), decorator
*Pair of Covered Urns with Portraits of
Louis XVI and Marie Antoinette*
Soft-paste porcelain, underglaze and
overglaze enamels, gilt and ormolu
dated 1756; decorated after 1800
Private Collection, Columbia SC

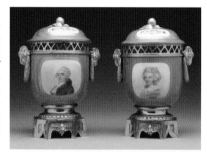
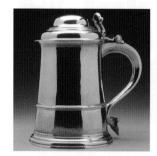

27. Fuller White
English; active in London, 1744-1775
Tankard
Silver, 1760
Private Collection, Blythewood SC

23. Sèvres Porcelain Manufactory or "Old Paris"
French
Pair of Urns with Bird and Floral Decorations
Hard-paste porcelain with gilt and overglaze
polychrome enamels, c. 1810-1820
Private Collection, Richland County SC

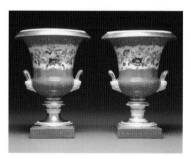

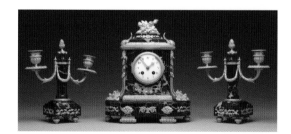

24. Tiffany and Company; French; Paris; *Garniture Clock and Candlesticks*
Marble, ormolu and enamel, 1890-1910; Private Collection, Columbia SC

25. Wedgwood Pottery
English; active 1759-present
*Mug with Profiles of George Washington and
Benjamin Franklin*
Jasperware, 19th century
Private Collection, SC

28. Gustave-Henri Aubain
French, dates unknown
Rebecca
Oil on canvas, 1912
Collection of Mike Thomas, Columbia SC

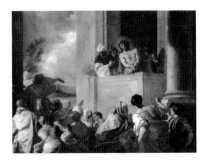

33. Paul Delaroche
French, 1797-1856
The Death of Queen Elizabeth
Oil on canvas, 1828
Collection of Mike Thomas, Columbia SC

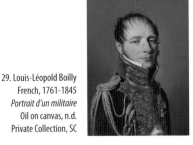

29. Louis-Léopold Boilly
French, 1761-1845
Portrait d'un militaire
Oil on canvas, n.d.
Private Collection, SC

34. Francesco De Mura
Italian, 1696-1782
Ecce Homo
Oil on canvas, c. 1725-1727
Private Collection, Greenville SC

30. Henry Pierce Bone
English, 1779-1855
William Henry, Late Lord Lyttelton
Enamel on metal, 1834
Private Collection, SC

35. David Emile Joseph de Noter
Belgian, 1825-1912
and Louis Benoît Antoine Tuerlinckx
Belgian, 1820-1894
A Maid Seated in a Kitchen
Oil on panel, 1852
Collection of Mr. and Mrs.
Donald R. Tomlin, Jr., Columbia SC

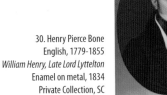

31. Jean-Baptiste-Camille Corot; French, 1796-1875; *Pastoral Landscape at Sunset*
Oil on canvas, c. 1870; Collection of Joyce and Bob Hampton, Blythewood SC

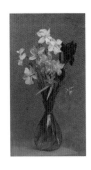

36. Henri Fantin-Latour
French, 1836-1914
Jonquils and Narcisses
Oil on canvas, 1885
Private Collection, Colleton County SC

32. Edgar Degas
French, 1834-1917
Jockeys at Epsom
Oil on canvas, c. 1860-1862
Private Collection, Colleton County SC

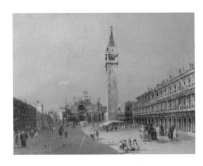

37. Francesco Guardi
Italian, 1712-1793
Piazza San Marco
Oil on panel, c. 1780
Private Collection, Colleton County SC

38. Henry Howard
English, 1769-1847
Portrait of Caroline Carey
Oil on canvas, 1819
Private Collection, Murrells Inlet SC

43. Pierre Auguste Renoir
French, 1841-1919
Two Young Girls Wearing Hats
Oil on canvas, 1890
Private Collection, Colleton County SC

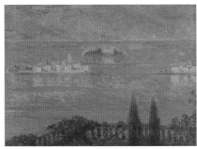

39. Henri Le Sidaner
French, 1862-1939
Les Iles Borromées, Stresa
Oil on canvas, 1909
Private Collection, Blythewood SC

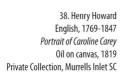

44. Charles Joseph Frederic Soulacroix
French, 1825-c. 1900
The Afternoon Visitor
Oil on canvas, c. 1870
Collection of Mr. and Mrs. Donald R. Tomlin, Jr.,
Columbia SC

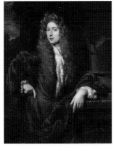

40. Nicolaes Maes
Dutch, 1632-1693
*Portrait of a Gentleman,
Three-Quarter Length, Wearing a Red Mantle*
Oil on canvas, c. 1670-1680
Private Collection, SC

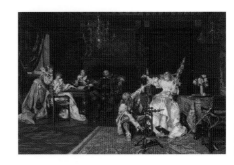

45. Edouard Alexandre Simon Toudouze
French, 1848-1907
Young Courtship with Parental Approval
Oil on canvas, 1881
Collection of Mr. and Mrs.
Donald R. Tomlin, Jr., Columbia SC

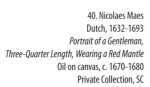

41. Charlotte Nasmyth
English, 1804-1884
Dutch Landscape
Oil on panel, n.d.
Collection of Max Gergel and Pat Foster,
Columbia SC

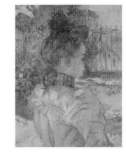

46. Henri de Toulouse-Lautrec
French, 1864-1901
Mlle Béatrice Tapié de Céleyran
Oil and peinture á l'essence on board, 1897
Private Collection, Colleton County SC

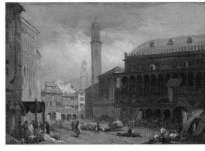

42. Edward Pritchett
English, active c. 1828-1864
View of Piazza dei Signori, Verona
Oil on panel, n.d.
Collection of Max Gergel and Pat Foster,
Columbia SC

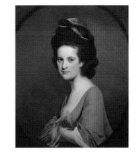

47. Joseph Wright of Derby
English, 1734-1797
Portrait of Mrs. Dorothy Hodges
Oil on canvas, c. 1775-1777
Private Collection, SC

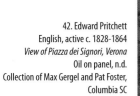
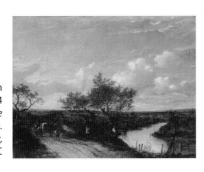
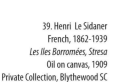

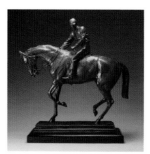

48. Isidore Jules Bonheur
French, 1827-1901
Le grand jockey
Bronze, n.d.
Private Collection, Florence SC

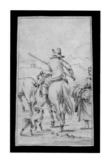

53. Gaston Veuvenot Leroux
French, 1854-1942
Hetaera (After the Bath)
Bronze, c. 1920
Collection of Dr. Richard and Dr. Betty Mandell, Columbia SC

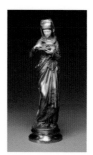

49. Albert-Ernest Carrier-Belleuse
French, 1824-1887
Liseuse
Patinated bronze and ivory, n.d.
Collection of Mike Thomas, Columbia SC

........................works on paper

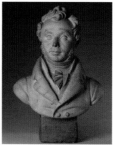

50. Joseph Chinard
French, 1756-1813
Bust of a Man
Terra-cotta, c. 1795
Private Collection, SC

54. Nicolaes Berchem
Dutch, c. 1620-1683
Peasants in the Roman Campagna
Pen with brown ink and wash on tan paper, c. 1660
Collection of Charles and Ilona Mack, Columbia SC

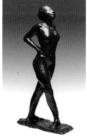

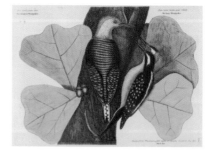

51. Edgar Degas
French, 1834-1917
Danseuse au repos, les mains sur les reins, la jambe droite en avant
Bronze, n.d.
Private Collection, Colleton County SC

55. Mark Catesby
English, 1683-1749
The Red-Bellied Wood-Pecker and the Hairy Wood-Pecker, from vol.1 of *"The Natural History of Carolina, Florida, and the Bahama Islands"*
Hand-colored engraving, 1731
Collection of a Member of the Gibbes Family, Columbia SC

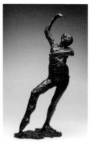

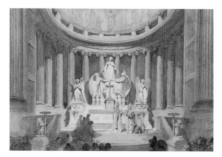

52. Edgar Degas
French, 1834-1917
Danse espagnol
Bronze, n.d.
Private Collection, Colleton County SC

56. Alfred Charles Conrade
English, 1863-1955
Church of the Madeleine
Pencil and watercolor on paper, n.d.
Collection of Mike Thomas, Columbia SC

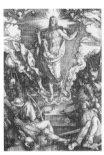

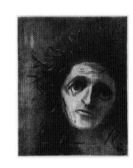

57. Albrecht Dürer
German, 1471-1528
Resurrection
Woodcut, 1511
The Bowden Collection, Hilton Head SC

62. Jules Pascin
French (born Bulgaria), 1885-1930
Figure Study
Pencil on paper, 1911
Collection of Joe and Melissa Blanchard, Columbia SC

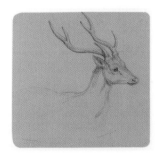

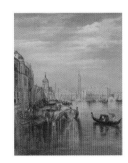

58. Gustave Jean Jacquet
French, 1846-1909
A Young Beauty in a White Dress
Oil on paper laid on board, c. 1870
Private Collection, SC

63. Odilon Redon
French, 1840-1916
Christ
Lithograph, 1887
The Bowden Collection, Hilton Head SC

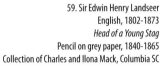

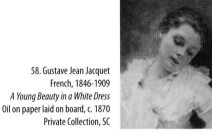

59. Sir Edwin Henry Landseer
English, 1802-1873
Head of a Young Stag
Pencil on grey paper, 1840-1865
Collection of Charles and Ilona Mack, Columbia SC

64. David Roberts
Scottish, 1796-1864
Venetian Canal Scene
Watercolor and gouache on paper, 1847
Private Collection, Columbia SC

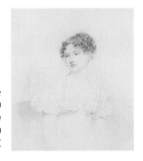

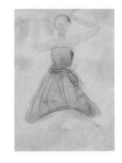

60. Sir Thomas Lawrence
English, 1769-1830
Portrait of an Unidentified Woman
Graphite and colored pencil on paper, c. 1810
Private Collection, Murrells Inlet SC

65. August Rodin
French, 1840-1917
Cambodian Dancer
Pencil and watercolor on paper, 1906
Collection of Bobby and Sally Lyles, Columbia SC

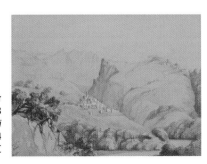

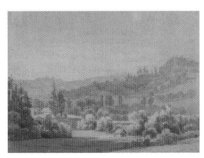

61. Edward Lear
English, 1812-1888
View of Cociglia and Casoli
Pen and ink with watercolor highlights, 1854
Collection of Harry and Dee Hansen, Columbia SC

66. Anthonie Waterloo
Flemish, c. 1610-1690
Mountain Valley Landscape
Pen, point of brush and black ink over graphite, grey wash, heightened with gouache, on blue-green oatmeal paper, c. 1670-1680
Collection of Charles and Ilona Mack, Columbia SC

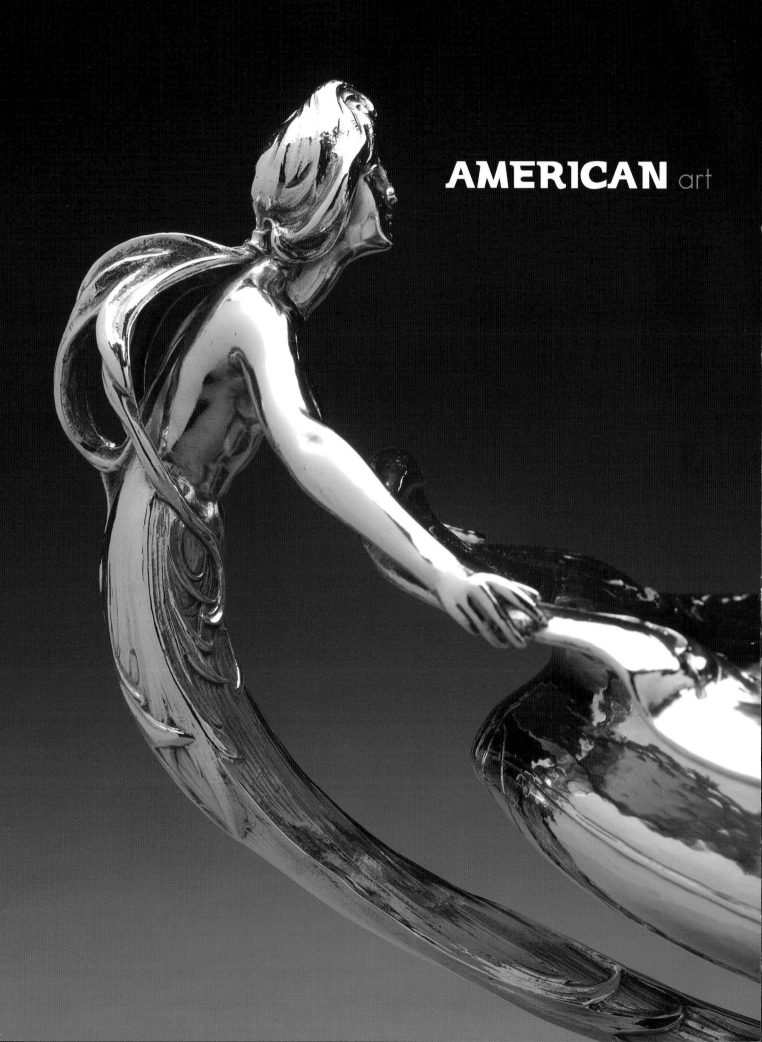

AMERICAN art

1. Anonymous
American; Charleston, South Carolina
Dressing Table
Mahogany, cypress and brass, 1745-1755
Private Collection, Columbia SC

6. Anonymous
American or English
Pier Mirror
Mahogany, mahogany veneer, gesso and gilt, 1770-1790
Collection of Mr. and Mrs. Robert H. Kennedy, Columbia SC

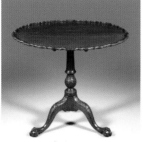

2. Anonymous
American; Charleston, South Carolina
Tea Table
Mahogany, 1755-1775
Private Collection, SC

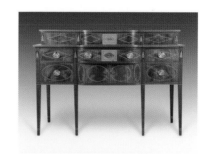

7. Anonymous
American; Newburyport, Massachusetts
Pair of Side Chairs
Mahogany, c. 1770-1790
Private Collection, Columbia SC

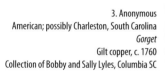

3. Anonymous
American; possibly Charleston, South Carolina
Gorget
Gilt copper, c. 1760
Collection of Bobby and Sally Lyles, Columbia SC

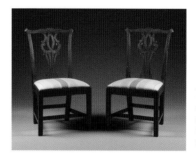

8. Anonymous
American; Charleston, South Carolina
Stage-Top Sideboard
Mahogany, mahogany veneers, poplar,
pine and ash, with holly and boxwood inlays,
c. 1800
The Rivers Collection, Charleston SC

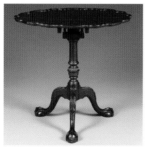

4. Anonymous
American; Philadelphia, Pennsylvania
Tea Table
Mahogany, 1760-1780
Private Collection, Aiken SC

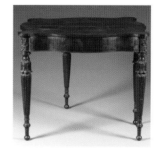

9. Anonymous
(carving attributed to Samuel Field McIntire,
American, 1780-1819)
American; Salem, Massachusetts
Card Table
Mahogany and pine, c. 1810
Private Collection, SC

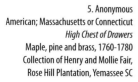

5. Anonymous
American; Massachusetts or Connecticut
High Chest of Drawers
Maple, pine and brass, 1760-1780
Collection of Henry and Mollie Fair,
Rose Hill Plantation, Yemassee SC

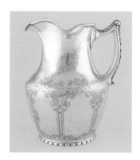

10. Baldwin and Company
American; Newark, New Jersey; active 1840-1869
Water Pitcher
Silver, c. 1855-1860
Collection of Dr. and Mrs. John D. LeHeup, Belton SC

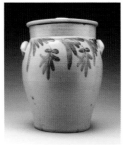

11. Solomon Bell
American, 1817-1882; active in Strasburg, Virginia
Lidded Jar
Salt-glazed stoneware, c. late 1840s-1860s
Collection of Myrna Kennedy, Union SC

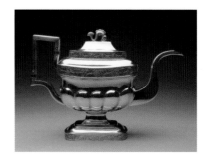

16. John Ewan
American, 1786-1852; active in Charleston,
South Carolina, 1823-1852
Teapot
Silver, c. 1825
Collection of Dr. and Mrs. John D. LeHeup, Belton SC

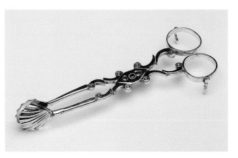

12. Miles Brewton (attributed to)
English/American (born Barbados),
1675-1745;
active in Charleston, South Carolina
Sugar Nips, Silver, c. 1740
Collection of W.R. Sikes III,
Orangeburg SC

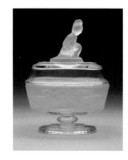

17. Gillinder and Sons
American; Philadelphia, Pennsylvania
"Pioneer" or *"Westward Ho" Compote and Lid*
Pressed and acid etched glass, c. 1878
Private Collection, Aiken SC

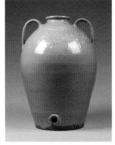

13. Thomas M. Chandler
American, 1810-1854
Chandler Pottery; Edgefield District, South Carolina
Watercooler
Alkaline-glazed stoneware with trailed kaolin slip decoration,
c. 1850-1852
The Ferrell Collection, Edgefield SC

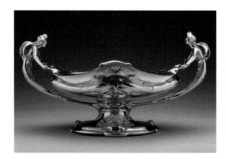

18. Gorham Manufacturing Company,
American; Providence, Rhode Island;
active 1865-1961
Spaulding and Company;
Chicago, Illinois; retailer
Martelé Centerpiece
Silver, c. 1900
Collection of Joyce and Bob Hampton,
Blythewood SC

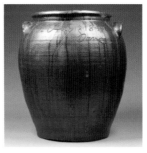

14. Dave ("the Potter") Drake
American, c. 1800-c. 1870
Lewis Miles Pottery; Edgefield District, South Carolina
Storage Jar
Alkaline-glazed stoneware, 1857
The Ferrell Collection, Edgefield SC

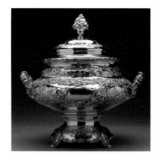

19. Gregg, Hayden & Company
American; Charleston, South Carolina
Tureen and Cover
Silver, c. 1840-1850
The Rivers Collection, Charleston SC

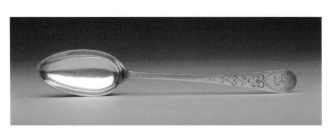

15. Thomas Stevens Eayres; American, 1760-1813
Teaspoon; Silver, c. 1800; Collection of W.R. Sikes III, Orangeburg SC

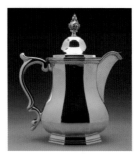

20. Gregg, Hayden & Company
American; Charleston, South Carolina
Cream Pitcher
Silver, c. 1850
Collection of Myrna Kennedy, Union SC

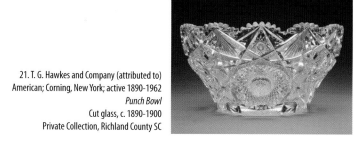

21. T. G. Hawkes and Company (attributed to)
American; Corning, New York; active 1890-1962
Punch Bowl
Cut glass, c. 1890-1900
Private Collection, Richland County SC

26. Paul Revere; American, 1734-1818; *Coffin-End Tablespoon*; Silver, c. 1800
Collection of W.R. Sikes III, Orangeburg SC

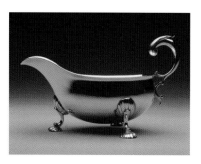

22. John Mood
American, 1792-1864
active in Charleston, South Carolina, 1813-1864
Gravy Boat
Silver, c. 1830
Private Collection, Columbia SC

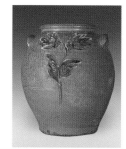

27. Milton Rhodes
American, dates unknown
Collin Rhodes Pottery; Edgefield District, South Carolina
Storage Jar
Alkaline-glazed stoneware with brushed iron and trailed kaolin slip decoration, c. 1850-1852
The Ferrell Collection, Edgefield SC

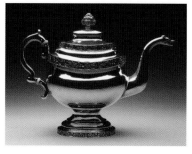

23. Pelletreau, Bennett & Cooke
American; New York, New York;
working in partnership, 1825-1828
Teapot
Silver, 1825-1828
Collection of Mr. and Mrs.
Frederick Reeves Rutledge, Columbia SC

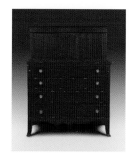

28. John Seymour and Thomas Seymour (attributed to)
American (born England), 1738-1818;
American (born England), 1771-1847;
active in Boston, Massachusetts, 1793-1824
Tambour Desk
Mahogany, white pine and inlay, c. 1800
Collection of Henry and Mollie Fair,
Rose Hill Plantation, Yemassee SC

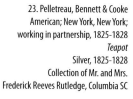 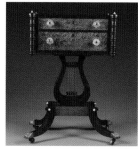

24. Duncan Phyfe (attributed to)
American (born Scotland), 1768-1854;
active in New York, New York, 1791-1854
Worktable with Lyre Base
Mahogany, birds-eye maple, pine, gilt brass, glass and ivory, c. 1815
Collection of Darnall and Susan Boyd, Columbia SC

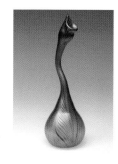

29. Louis Comfort Tiffany
American, 1848-1933
Tiffany Glass and Decorating Company
American; New York, New York; active 1892-1928
Goose-Neck Vase (or "Persian Rosewater Sprinkler")
Favrile glass, c. late 1890s-1901
Collection of Jack S. and Elaine Folline, Columbia SC

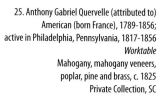 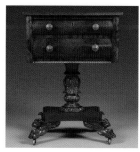

25. Anthony Gabriel Quervelle (attributed to)
American (born France), 1789-1856;
active in Philadelphia, Pennsylvania, 1817-1856
Worktable
Mahogany, mahogany veneers, poplar, pine and brass, c. 1825
Private Collection, SC

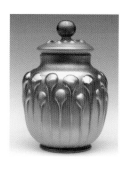

30. Louis Comfort Tiffany
American, 1848-1933
Tiffany Glass and Decorating Company or Tiffany Studios
American; New York, New York; active 1892-1928
Covered Jar with Lily Pad Decorations
Favrile glass, c. 1900-1915
Collection of Jack S. and Elaine Folline, Columbia SC

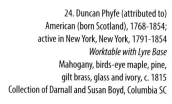

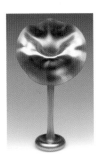

31. Louis Comfort Tiffany
American, 1848-1933
Tiffany Glass and Decorating Company or Tiffany Studios
American; New York, New York; active 1892-1928
"Jack-in-the-Pulpit" Vase
Favrile glass, c. 1900-1915
Collection of Jack S. and Elaine Folline, Columbia SC

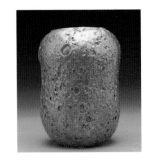

35. Louis Comfort Tiffany
American, 1848-1933
Tiffany Glass and Decorating Company or Tiffany Studios
American; New York, New York; active 1892-1928
Lava Glass Vase
Favrile glass, c. 1925
Collection of Jack S. and Elaine Folline, Columbia SC

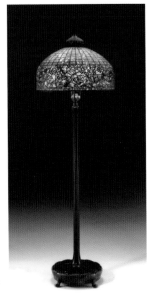

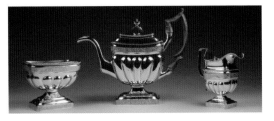

36. Whiting Manufacturing Company
American; North Attleboro, Massachusetts;
active 1866-1924
Punch Bowl, Undertray and Ladle
Silver and gilt, c. 1890
Collection of Dr. and Mrs. John D. LeHeup, Belton SC

32. Louis Comfort Tiffany
American, 1848-1933
Tiffany Studios
American; New York, New York; active 1902-1928
Peony Floor Lamp
Favrile glass and bronze, c. 1904-1915
Collection of Jack S. and Elaine Folline, Columbia SC

37. Samuel Williamson; American, 1772-1843; active in Philadelphia, Pennsylvania, 1794-1813;
Teapot, Creamer and Sugar Bowl; Silver, c. 1810; Private Collection, SC

33. Louis Comfort Tiffany
American, 1848-1933
Tiffany Studios
American; New York, New York; active 1902-1928
Pair of Candlesticks
Bronze, c. 1910
Collection of Jack S. and Elaine Folline, Columbia SC

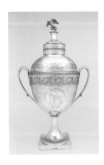

38. Samuel Williamson, maker
American, 1772-1843; active in Philadelphia, Pennsylvania, 1794-1813
Charles A. Burnett (American, 1760-1849) and
John E. Rigden (American, w.c. 1796-1831), retailer
Georgetown, District of Columbia; working in partnership, 1796-1806
Punch Urn Trophy
Silver with gilt interior, 1803
Private Collection, Columbia SC

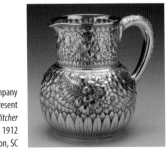

34. Tiffany and Company
American; New York, New York; active 1853-present
Water Pitcher
Silver, 1912
Private Collection, SC

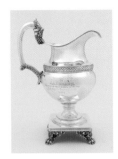

39. Alexander Young
American (born Scotland), 1784-1856;
active in Camden, South Carolina, 1807-1856
Ewer or Water Pitcher
Silver, c. 1820
Collection of Dr. and Mrs. John D. LeHeup, Belton SC

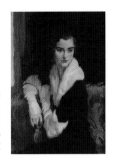

40. Cecilia Beaux
American, 1855-1942
Lady in the White Gloves (Flora Whitney)
Oil on canvas, 1916
Private Collection, Aiken SC

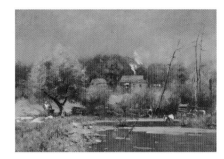

45. William Gilbert Gaul
American, 1855-1919
Van Buren, Tennessee
Oil on canvas, c. 1881
The Johnson Collection, Spartanburg SC

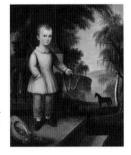

41. George Esten Cooke
American, 1793-1849
Joseph Fairfax Lapsley
Oil on canvas, 1848
The Johnson Collection, Spartanburg SC

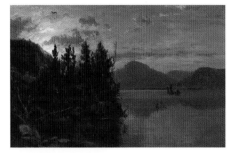

46. Regis François Gignoux
American (born France), 1816-1882
Sunset at Lake George
Oil on canvas, c. 1850s
Collection of John and Kay Bachmann, SC

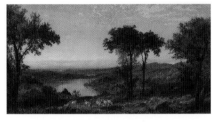

42. Jasper Francis Cropsey; American, 1823-1900; *Landscape (Autumn)*
Oil on canvas, 1870s; Collection of John and Kay Bachmann, SC

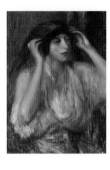

47. William J. Glackens
American, 1870-1938
A Portrait (of Mrs. Glackens)
Oil on canvas, c. 1915-1920
Wright Southern Collection, Charleston SC

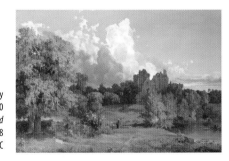

43. Jasper Francis Cropsey
American, 1823-1900
Doune Castle, Scotland
Oil on canvas, 1848
Collection of John and Kay Bachmann, SC

48. Edmund William Greacen
American, 1876-1949
The Farm, Giverny
Oil on canvas, 1907
Private Collection, Columbia SC

44. Charles Demuth
American, 1883-1935
Coastal Scene
Oil on canvas, c. 1914
Collection of Nancy Slocum, Columbia SC

49. Martin Johnson Heade
American, 1819-1904
Still Life with Cherokee Roses in a Glass
Oil on canvas, c. 1883-1895
Wright Southern Collection, Charleston SC

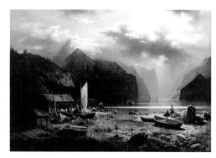

50. Herman Herzog
American (born Germany), 1832-1932
Fishing Village
Oil on canvas, 1862
Collection of John and Kay Bachmann, SC

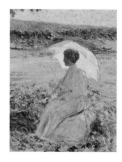

55. Lilla Cabot Perry
American, 1848-1933
Lady with White Parasol
Oil on canvas, n.d.
Private Collection, Columbia SC

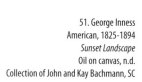

51. George Inness
American, 1825-1894
Sunset Landscape
Oil on canvas, n.d.
Collection of John and Kay Bachmann, SC

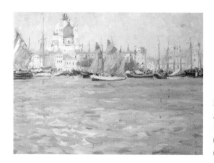

56. Jane Peterson
American, 1876-1965
View of Venice
Oil on canvas, c. 1910
Collection of John and Kay Bachmann, SC

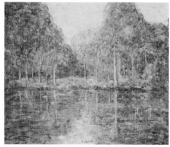

52. Ernest Lawson
American (born Canada), 1873-1939
Cypress Grove
Oil on canvas, c. 1910
Private Collection, SC

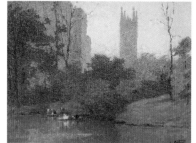

57. Edward Henry Potthast
American, 1857-1927
Boating, Central Park
Oil on panel, c. 1915-1920
Private Collection, Columbia SC

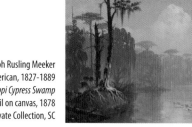

53. Joseph Rusling Meeker
American, 1827-1889
Mississippi Cypress Swamp
Oil on canvas, 1878
Private Collection, SC

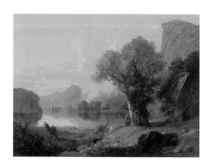

58. William T. Russell Smith
American (born Scotland), 1812-1896
Landscape with the Old Man in the Mountain
Oil on canvas, 1864
Private Collection, SC

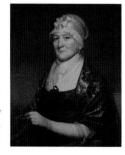

54. Charles Willson Peale
American, 1741-1827
Portrait of Catherine Kimbell
Oil on canvas, c. 1790
Collection of Ms. Meredith Mann Maynard, Columbia SC

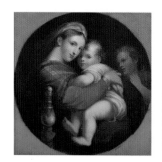

59. Thomas Sully
American (born England), 1783-1872
Holy Family (after Raphael's *Madonna della Sedia*)
Oil on canvas, 1809
Private Collection, Columbia SC

60. Louis Comfort Tiffany
American, 1848-1933
The Fishmongers
Oil on panel, c. 1910
Collection of Jack S. and Elaine Folline, Columbia SC

······················ sculptures

61. William Aiken Walker
American, 1838-1921
Nature Morte: Quail
Oil on panel, c. 1880
Private Collection, Columbia SC

64. Jo Davidson
American, 1883-1952
Flora Payne Whitney
Bronze, 1909
Private Collection, Aiken SC

62. William Dickinson Washington
American, 1833-1870
Study for Marion's Camp
Oil on canvas, c. 1859
The Johnson Collection, Spartanburg SC

65. Frederick William MacMonnies
American, 1863-1937
Dancing Bacchante and Infant Faun
Bronze, 1893
Private Collection, SC

63. Thomas Worthington Whittredge
American, 1820-1910
Cottage Garden with Hollyhocks
Oil on canvas, n.d.
Private Collection, SC

66. Augustus Saint-Gaudens
American (born Ireland), 1848-1907
Samuel Johnson
Plaster, 1874
Private Collection, SC

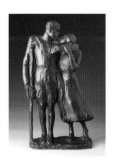

67. Gertrude Vanderbilt Whitney
American, 1875-1942
Homecoming (Soldier and Woman)
Bronze, 1919
Private Collection, Aiken SC

works on paper

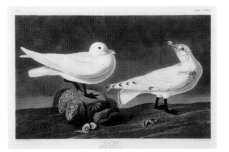

68. John James Audubon
American (born West Indies), 1785-1851
Ivory Gull from *"The Birds of America,"*
Havell Edition (1835)
Hand-colored engraving, 1835
Collection of a Columbia Poet

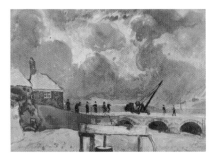

73. Richard Hayley Lever
American, 1876-1958
St. Ives, Cornwall, England
Watercolor on paper, 1904
Private Collection, Blythewood SC

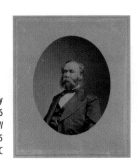

69. Mathew B. Brady
American, 1822-1896
Wade Hampton III
Albumen print, 1865
Private Collection, Columbia SC

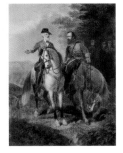

70. Frederick W. Halpin
American, 1805-1880
The Last Meeting of Lee and Jackson (after the painting
by Everett B.D. Fabrino Julio, American, 1843-1879)
Steel engraving, 1873
Collection of a Member of the Gibbes Family, Columbia SC

71. Frederick Childe Hassam
American, 1859-1935
Cos Cob
Pastel on paper, 1902
Private Collection, Columbia SC

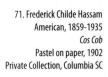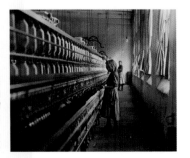

72. Lewis Wickes Hine
American, 1874-1940
Young Girl in a Carolina Cotton Mill
Gelatin silver print, 1908 (printed c. 1930)
Collection of Dr. and Mrs. Donald E. Saunders, Jr.,
Columbia SC

MODERNand
CONTEMPORARY art

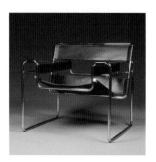

1. Alvar Aalto
Danish, 1898-1976
Aalto Vase (Savoy Vase)
Colored glass, designed 1936 (this example c. 1990)
Collection of Bobby and Sally Lyles, Columbia SC

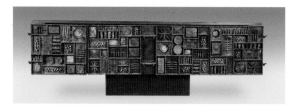

6. Paul Evans; American, 1931-1987; Manufactured by the Paul Evans Studio
Sideboard; from the *"Sculpted Front"* series; Mixed media sculpture: welded steel, wood, polychrome enamels,
gold leaf, and Pennsylvania slate, c. 1975; Collection of Dr. and Mrs. Donald E. Saunders, Jr., Columbia SC

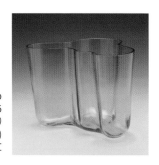

2. Marcel Lajos Breuer
American (born Hungary), 1902-1981
Model B3 Chair ("Wassily" Chair)
Tubular steel and leather, designed 1925-1926
(this example c. 1960)
Collection of Dr. and Mrs. Donald E. Saunders, Jr.,
Columbia SC

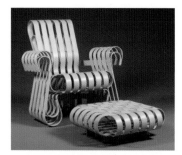

7. Frank O. Gehry
American (born Canada), 1929
Manufactured by Knoll International, Inc.;
East Greenville, Pennsylvania; active 1938-present
*Power Play Armchair (94L-GC) and
Off Side Ottoman (94LY-GC)*
Maple laminate, designed 1992
Collection of Bobby and Sally Lyles, Columbia SC

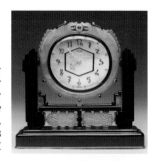

3. Clay Burnette
American, born 1951
Tripod Basket
Dyed and painted longleaf pine needles,
waxed linen thread and beeswax, n.d.
Collection of Dr. and Mrs. Donald E. Saunders, Jr.,
Columbia SC

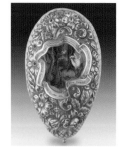

8. Robin Kranitsky and Kim Overstreet
American, born 1956; American, born 1955;
working in partnership 1985-present
Pelléas and Mélisande (Brooch #1679)
Mixed media, 1997
Porter.Price Collection, Columbia SC

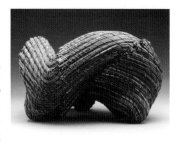

4. Louis François Cartier (1875-1942), retailer
Maurice Couët (French, 1885-1963), maker
Charles Jacqueau (French, 1885-1986), designer
Clock in the Chinese Taste
Jade, black onyx, mother-of-pearl, coral, diamonds,
sapphires, platinum, gold, and black enamel, 1928
Private Collection, SC

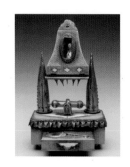

9. Robin Kranitsky and Kim Overstreet
American, born 1956; American, born 1955;
working in partnership 1985-present
Allure (Brooch #1678)
Mixed media, 1997
Porter.Price Collection, Columbia SC

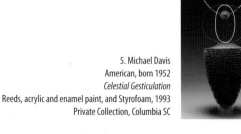

5. Michael Davis
American, born 1952
Celestial Gesticulation
Reeds, acrylic and enamel paint, and Styrofoam, 1993
Private Collection, Columbia SC

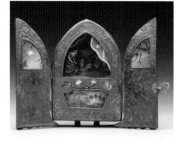

10. Robin Kranitsky and Kim Overstreet
American, born 1956; American, born 1955;
working in partnership 1985-present
Moment (Brooch #1656)
Mixed media, 1994
Porter.Price Collection, Columbia SC

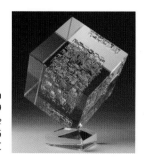

11. Jon Kuhn
American, born 1949
"Bertica" Cube
Cold glass, 1996
Private Collection, Columbia SC

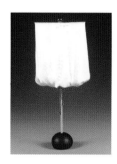

16. Isamu Noguchi
American, 1904-1988
Akari Table Lamp, Model BB2/K1
Indian silk, bamboo and cast iron, designed c. 1951
(this example c. 1990)
Collection of Bobby and Sally Lyles, Columbia SC

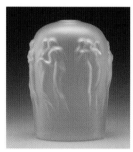

12. René Jules Lalique
French, 1860-1945
Bath Salts Bottle
Molded and etched glass, c. 1925
Collection of Bobby and Sally Lyles, Columbia SC

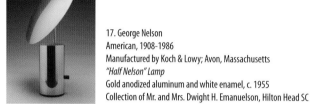

17. George Nelson
American, 1908-1986
Manufactured by Koch & Lowy; Avon, Massachusetts
"Half Nelson" Lamp
Gold anodized aluminum and white enamel, c. 1955
Collection of Mr. and Mrs. Dwight H. Emanuelson, Hilton Head SC

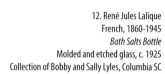

13. René Jules Lalique
French, 1860-1945
Pair of Candlesticks
Molded and etched glass, c. 1930
Private Collection, Aiken SC

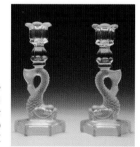

18. Kenny Pieper
American, born 1959
Sandey
Blown and molded glass, 2005
Collection of Brenda and Rick Wheeler, Columbia SC

14. Le Corbusier, (French, born Switzerland,
1887-1965),
Pierre Jeanneret, (Swiss, 1896-1967) and
Charlotte Perriand (French, 1903-1999)
Manufactured by Cassina S.p.A.; Milan, Italy;
active 1927-present
Chaise Longue (Model Number B306)
Chromium-plated and painted metal, pony hide
and leather, designed 1928 (this example c. 1965)
Collection of Dr. and Mrs. Donald E. Saunders, Jr.,
Columbia SC

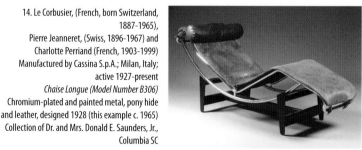

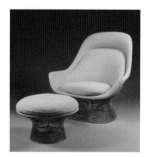

19. Warren Platner
American, 1919-2006
Manufactured by Knoll International, Inc.;
East Greenville, Pennsylvania; active 1938-present
Lounge Chair and Ottoman
Chrome-plated and welded steel wire and original
upholstery, designed 1966 (this example c. 1975)
Collection of Dr. and Mrs. Donald E. Saunders, Jr.,
Columbia SC

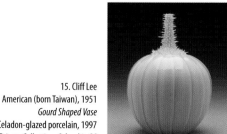

15. Cliff Lee
American (born Taiwan), 1951
Gourd Shaped Vase
Celadon-glazed porcelain, 1997
Private Collection, Columbia SC

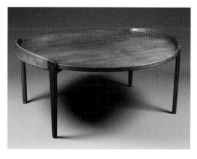

20. Jens Risom
American (born Denmark), 1916
Manufactured by Jens Risom Design, Inc.;
New York, New York; active 1946-1971
Low Table (Model Number 4035)
Walnut, early 1960s
Private Collection, Columbia SC

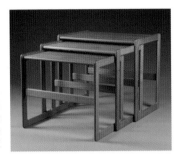

21. Terence Harold Robsjohn-Gibbings (attributed to)
English, 1905-1976
Set of Three Nesting Tables
Teak, c. 1950
Private Collection, Columbia SC

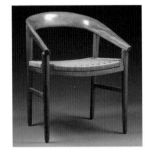

26. Hans J. Wegner
Danish, 1914-2007
Armchair
Teak and woven cane, c. 1950
Collection of Mr. and Mrs. Dwight H. Emanuelson, Hilton Head SC

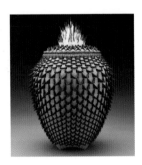

22. JoAnne Russo
American, born 1956
Porcupine Basket #1059
Black ash, pine needles and porcupine quills, 2001
Private Collection, Columbia SC

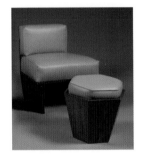

27. Frank Lloyd Wright
American, 1867-1959
General Purpose Chair and Dining Stool
Stained cypress and leather, c. 1946
Collection of Auldbrass Plantation, Yemassee SC

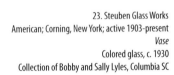

23. Steuben Glass Works
American; Corning, New York; active 1903-present
Vase
Colored glass, c. 1930
Collection of Bobby and Sally Lyles, Columbia SC

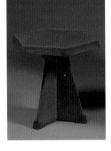

28. Frank Lloyd Wright
American, 1867-1959
Hexagon Table
Stained cypress, c. 1946
Collection of Auldbrass Plantation, Yemassee SC

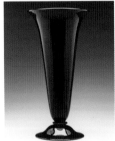

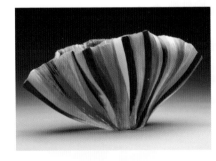

24. Lino Tagliapietra
Italian, born 1934
Vase
Carved glass, 1998
Private Collection, Columbia SC

29. Mary Ann "Toots" Zynsky
American, born 1951
Striking Chaos Again
Fused and thermo-formed glass threads, 1995
(*Maestrale* and *fillets de verre*)
Private Collection, Columbia SC

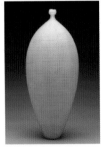

25. Toshiko Takaezu
American, born 1922
Vase
Glazed stoneware, c. 1990
Collection of Bobby and Sally Lyles, Columbia SC

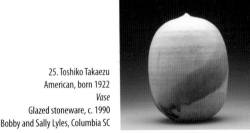

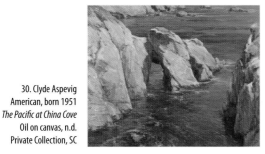

30. Clyde Aspevig
American, born 1951
The Pacific at China Cove
Oil on canvas, n.d.
Private Collection, SC

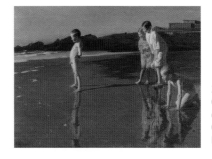

35. Alfredo Castañeda
Mexican, born 1938
Sorprendido en mis recuerdos
Oil on canvas, 1980
Collection of Edwin R. Wallace IV, M.D., and Neeta Shah, Irmo SC

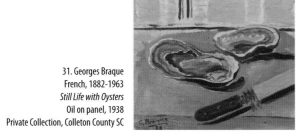

31. Georges Braque
French, 1882-1963
Still Life with Oysters
Oil on panel, 1938
Private Collection, Colleton County SC

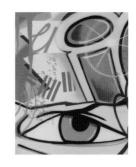

36. Benito Rebolledo Correa
Chilean, 1881-1964
Children on the Beach at Sunset, Valencia
Oil on canvas, 1909
Private Collection, SC

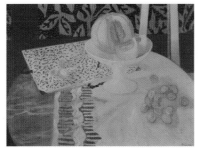

32. Maurice Brianchon
French, 1899-1979
Still Life
Oil on canvas, c. 1960s
Private Collection, Colleton County SC

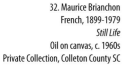

37. Crash (born John Matos)
American, born 1961
Untitled
Spray paint on canvas, c. 1984
Collection of Mr. and Mrs. Ben Arnold, Columbia SC

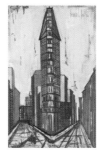

33. Bernard Buffet
French, 1928-1999
Study for Flat Iron Building
Oil on canvas, 1958
Porter.Price Collection, Columbia SC

38. Gene Davis
American, 1920-1985
Sky Window
Acrylic on canvas, 1981
Private Collection, SC

34. James Busby
American, born 1973
Two Hundred Fifteen
Gesso and spray paint on Polycast acrylic, 2008
Private Collection, SC; Courtesy of Stux Gallery,
New York, New York

39. Gabriel Delponte
Argentinian, born 1975
Zone
Resin, 2004
Collection of Mr. and Mrs. Ben Arnold,
Columbia SC

paintings

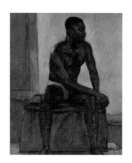

40. Aaron Douglas
American, 1898-1979
The Athlete
Oil on canvas, 1959
The Johnson Collection, Spartanburg SC

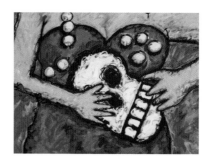

45. Gronk (born Glugio Nicondra)
American, born 1954
Broken ~~Blossoms~~ Beads
Oil on canvas, 1986
Porter.Price Collection, Columbia SC

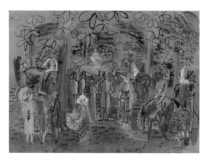

41. Raoul Dufy
French, 1877-1953
At the Races
Gouache, watercolor and pen and
ink on board, c. 1941
Private Collection, Lancaster SC

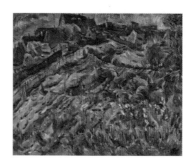

46. William Henry Johnson
American, 1901-1970
Garden, Kerteminde
Oil on burlap, c. 1930-1931
The Johnson Collection, Spartanburg SC

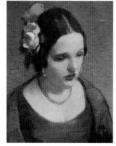

42. Nicolai Ivanovich Fechin
American (born Russia), 1881-1955
La Señorita
Oil on masonite, c. 1930
Private Collection, Columbia SC

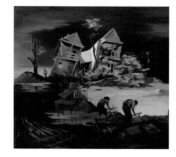

47. Georges Schreiber
American (born Belgium), 1904-1977
After the Charleston, South Carolina, Tornado
Oil on canvas, 1939
Private Collection, Columbia SC

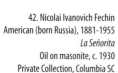

43. Lucio Fontana
Italian (born Argentina), 1899-1968
Untitled
Oil on canvas, c. 1959
Private Collection, Aiken SC

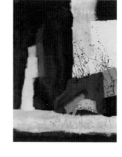

48. Robert Motherwell
American, 1915-1991
Untitled (Le gouffre)
Mixed media collage, c. 1980
Private Collection, Aiken SC

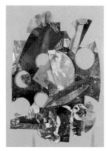

44. Sam Gilliam
American, born 1933
Yellow Wall
Mixed media, 2000
Collection of Edwin R. Wallace IV, M.D., and Neeta Shah
Irmo, SC

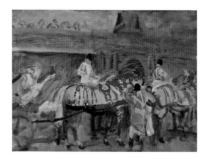

49. Sir Alfred Munnings
English, 1878-1959
*The "Windsor Grays" Being Harnessed
to the Royal Coach*
Oil on panel, 1925
Private Collection, Aiken SC

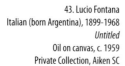

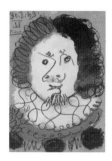

50. Pablo Picasso
Spanish, 1881-1973
Head of a Man
Mixed media: gouache, oil, and crayon on
cardboard, mounted onto canvas, 1969
Private Collection, Lancaster SC

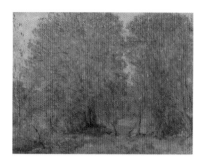

55. Guy Carleton Wiggins
American, 1883-1962
Summer Landscape
Oil on canvas, n.d.
Private Collection, Aiken SC

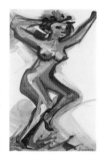

51. David Alfaro Siqueiros
Mexican, 1896-1974
Desnudo en movimiento
Pyroxilin on board, c. 1967
Collection of Edwin R. Wallace IV, M.D., and Neeta Shah
Irmo SC

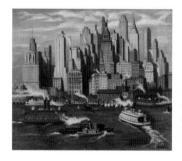

56. Edmund Yaghjian
American (born Armenia), 1903-1997
Lower Manhattan
Oil on canvas, c. 1930s
The Johnson Collection, Spartanburg SC

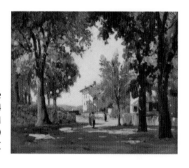

52. Anthony Thieme
American (born Holland), 1888-1954
Cape Ann, Rockport, MA
Oil on canvas, after 1929
Private Collection, Blythewood SC

sculptures

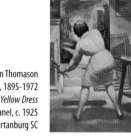

53. Eugene Healan Thomason
American, 1895-1972
Art Student in a Yellow Dress
Oil on panel, c. 1925
The Johnson Collection, Spartanburg SC

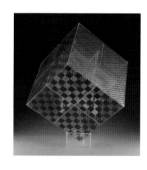

57. Richard Anuskiewicz (attributed to)
American, born 1930
Untitled
Acrylic on Plexiglass, c. 1960
Private Collection, Aiken SC

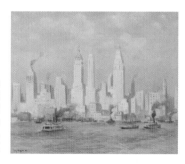

54. Guy Carleton Wiggins
American, 1883-1962
New York Skyline from a Staten Island Ferry Boat
Oil on canvas, c. 1940s
Collection of Mr. and Mrs. Frederick Reeves Rutledge,
Columbia SC

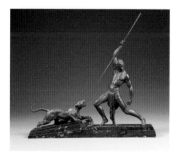

58. Demetre H. Chiparus
Romanian, 1888-1947
La Chasse
Patinated bronze, 1920-1925
Private Collection, SC

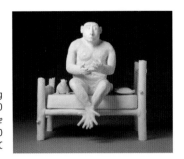

59. Frank Fleming
American, born 1940
Childhood Nightmare
Porcelain, 1990
Porter.Price Collection, Columbia SC

64. Peter Lenzo
American, born 1955
Seizure in the Garden
Mixed media: glazed ceramic, porcelain, found objects and wire, 2005
Porter.Price Collection, Columbia SC

60. Viola Frey
American, 1933-2004
Mask
Glazed ceramic, 1993
Porter.Price Collection, Columbia SC

65. Michael Lucero
American, born 1953
Jug Head (New World Series)
Glazed earthenware, 1992
Porter.Price Collection, Columbia SC

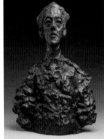

61. Alberto Giacometti
Swiss, 1901-1966
Bust of Isaku Yanaihara
Bronze, 1961
Private Collection, Colleton County SC

66. Akio Takamori
American (born Japan), 1950
Family
Salt-glazed stoneware, 1989
Porter.Price Collection, Columbia SC

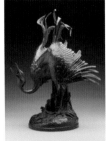

62. Anna Hyatt Huntington
American, 1876-1973
Angry Crane
Bronze, 1934
Collection of Mack and Jennifer Whittle, Greenville SC

67. Sirio Tofanari
Italian, 1886-1969
Gazelle
Bronze, n.d.
Private Collection, Blythewood SC

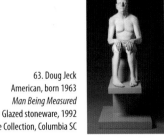

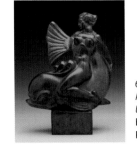

63. Doug Jeck
American, born 1963
Man Being Measured
Glazed stoneware, 1992
Porter.Price Collection, Columbia SC

68. Sidney Biehler Waugh
American, 1904-1963
Untitled (Woman and Porpoise)
Bronze, c. 1935
Private Collection, Aiken SC

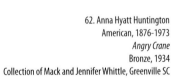

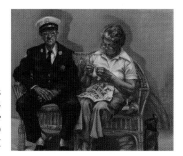

69. Sigmund Morton Abeles
American, born 1934
The Retired Fire Chief and His Wife
Pastel on paper, 1989
The Johnson Collection, Spartanburg SC

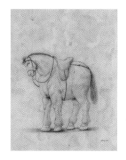

74. Fernando Botero
Colombian, born 1932
Horse (Caballo)
Pencil, charcoal and pastel on paper, 1998
Collection of Joyce and Bob Hampton, Blythewood SC

70. Richard Anuskiewicz
American, born 1930
Untitled
Color silkscreen, 1969
Collection of Dr. and Mrs.
Donald E. Saunders, Jr.,
Columbia SC

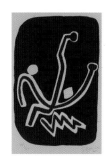

75. Georges Braque
French, 1882-1963
Oiseau de nuit
Color wood engraving, 1962
Private Collection, Columbia SC

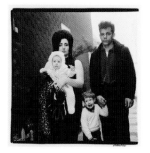

71. Diane Arbus
American, 1923-1971
Young Brooklyn Family Going on a Sunday Outing, NYC
Gelatin silver print, 1966
Private Collection, SC

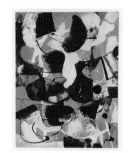

76. James Brooks
American, 1906-1992
Gouache #10
Gouache on paper, 1952
Collection of Mr. and Mrs. Dwight H. Emanuelson,
Hilton Head SC

72. Jennifer Bartlett
American, born 1941
Amagansett, December 2006
Pastel on paper, 2006
Collection of Mr. and Mrs. Dwight H. Emanuelson,
Hilton Head SC

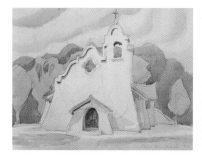

77. Charles Ephraim Burchfield
American, 1893-1967
Mission Church at Camden, S.C.
Watercolor and graphite on paper, 1918
Wright Southern Collection, Charleston SC

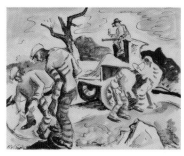

73. Thomas Hart Benton
American, 1889-1975
Chain Gang
Watercolor, ink and graphite on paper, 1928
Wright Southern Collection, Charleston SC

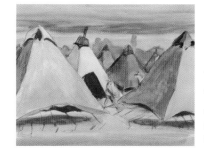

78. Charles Ephraim Burchfield
American, 1893-1967
Tents at Twilight (Camp Jackson, S.C.)
Watercolor and graphite on paper, 1918
Collection of Mack and Jennifer Whittle,
Greenville SC

79. Paul Cadmus
American, 1904-1999
Nude Male
Colored chalk and graphite on grey paper, 1954
Collection of Dr. and Mrs. Donald E. Saunders, Jr., Columbia SC

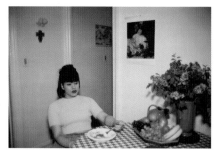

84. Nan Goldin
American, born 1953
Chicklet at Bruce's Dinner Party, New York
Cibachrome print, 1991
Private Collection, SC

80. Richard Diebenkorn
American, 1922-1993
Untitled (Ocean Park)
Color lithograph, 1970
Collection of Mr. and Mrs. Dwight H. Emanuelson, Hilton Head SC

85. Jasper Johns
American, born 1930
Alphabet
Lithograph, 1969
Collection of Dr. and Mrs. Donald E. Saunders, Jr.,
Columbia SC

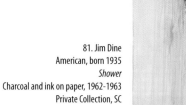

81. Jim Dine
American, born 1935
Shower
Charcoal and ink on paper, 1962-1963
Private Collection, SC

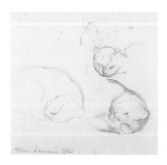

86. Wolf Kahn
American (born Germany), 1927
Barn in East Hampton, Long Island
Pastel on paper, 2005
Collection of Rick and Brenda Wheeler, Columbia SC

82. William Eggleston
American, born 1939
Morten, Mississippi
Dye transfer print, 1969-1970
Private Collection, SC

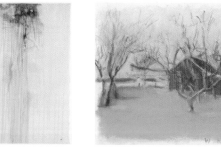

87. Marie Laurencin
French, 1883-1956
Studies of Cats
Pencil on paper, 1944
Collection of Joe and Melissa Blanchard, Columbia SC

83. Lucio Fontana
Italian (born Argentina), 1899-1968
Untitled
Crayon on paper, 1959
Private Collection, Aiken SC

88. Brice Marden
American, born 1938
Untitled
Pen and ink on paper, 1970
Private Collection, SC

89. Henri Matisse
French, 1869-1954
La nuit (Reclining Woman Sleeping)
Lithograph, 1922
Collection of Mr. and Mrs.
Dwight H. Emanuelson,
Hilton Head SC

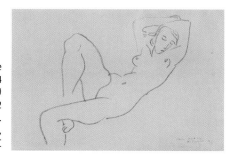

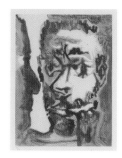

94. Pablo Picasso
Spanish, 1881-1973
Tête et Profil
Aquatint, 1964
Collection of Bobby and Sally Lyles, Columbia SC

90. Robert Motherwell
American, 1915-1991
Black with No Way Out
Lithograph, 1983
Collection of Mr. and Mrs.
Robert H. Kennedy,
Columbia SC

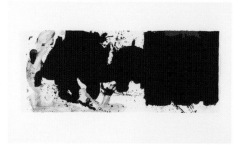

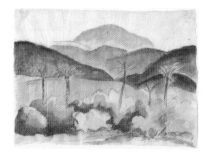

95. Diego Rivera
Mexican, 1886-1957
Mountain Landscape
Watercolor over charcoal, c. 1930
Collection of Edwin R. Wallace IV, M.D. and Neeta Shah,
Irmo SC

91. Louise Berliawsky Nevelson
American (born Russia), 1899-1988
Minneapolis Print
Lithograph with embossing, 1979
Private Collection, Columbia SC

96. Georges Rouault
French, 1871-1958
Christ de face
Sugarlift color aquatint, 1938
The Bowden Collection, Hilton Head SC

92. Jose Clemente Orozco
Mexican, 1883-1949
Study for "La Victoria"
Tempera on paper, 1945
Collection of Edwin R. Wallace IV, M.D., and
Neeta Shah, Irmo SC

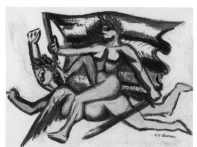

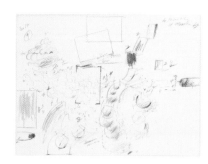

97. Wayne Theibaud
American, born 1920
Candy Apples
Color lithograph, 1987
Private Collection, Columbia SC

93. Frederic Ost
German, dates unknown
Untitled
Pen and ink on paper, 1934
Private Collection, Columbia SC

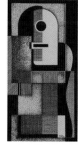

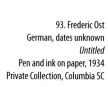

98. Cy Twombly
American, born 1928
*St. Maarten (Aerial View of the
House of Jasper Johns)*
Pencil and crayon on paper, 1969
Private Collection, SC

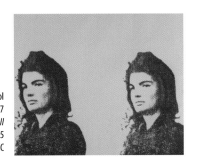

99. Andy Warhol
American, 1928-1987
Jacqueline Kennedy II
Screenprint in colors, 1965
Collection of Bobby and Sally Lyles, Columbia SC

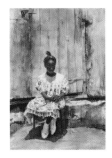

104. Stephen Scott Young
American, born 1958
Sunday Shoes
Watercolor and graphite on paper, 1994
Wright Southern Collection, Charleston SC

100. Tom Wesselmann
American, 1931-2004
Still Life with Radio
(from the *"New York Ten Series"*)
Embossed serigraph and pencil, 1965
Private Collection, Aiken SC

101. Edward Weston
American, 1886-1958
Boy on a Sofa
Gelatin silver print, c. 1925
Private Collection, SC

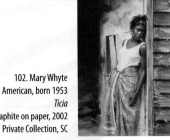

102. Mary Whyte
American, born 1953
Ticia
Watercolor and graphite on paper, 2002
Private Collection, SC

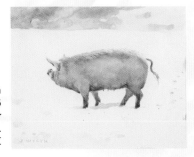

103. Jamie Wyeth
American, born 1946
Pig in Winter
Watercolor on paper, n.d.
Wright Southern Collection, Charleston SC